Goose
at the Beach

白鵝小菇去沙灘

Laura Wall

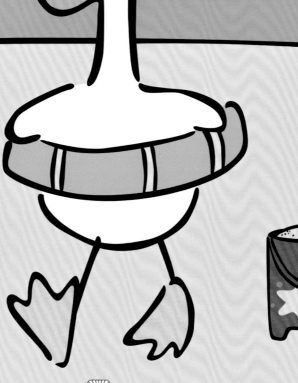

新雅文化事業有限公司
www.sunya.com.hk

Goose（白鵝小菇故事系列）

本系列共 6 冊，以貼近幼兒的語言，向孩子講述小女孩蘇菲與白鵝小菇的相遇和生活點滴。故事情節既輕鬆惹笑，又體現主角們彌足珍貴的友誼，能感動小讀者內心的柔軟，讓他們學懂發現生活中的小美好，做一個善良、溫柔的孩子。

此外，內文設有中、英雙語對照及四語點讀功能，包括英語、粵語書面語、粵語口語和普通話，能促進幼兒的語文能力發展。快來一起看蘇菲和小菇的暖心故事吧！

如何啟動新雅點讀筆的四語功能

請先檢查筆身編號：如筆身沒有編號或編號是 SY04C07、SY04D05，請先按以下步驟下載四語功能檔案並啟動四語功能；如編號第五個號碼是 E 或往後的字母，可直接閱讀下一頁，認識如何使用新雅閱讀筆。

1. 瀏覽新雅網頁 (www.sunya.com.hk) 或掃描右邊的 QR code 進入 新雅・點讀樂園 。

2. 點選 下載點讀筆檔案 ▶ 。

3. 依照下載區的步驟說明，點選及下載 *Goose*（白鵝小菇故事系列）框目下的四語功能檔案「update.upd」至電腦。

4. 使用 USB 連接線將點讀筆連結至電腦，開啟「抽取式磁碟」，並把四語功能檔案「update.upd」複製至點讀筆的根目錄。

5. 完成後，拔除 USB 連接線，請先不要按開機鍵。

6. 把點讀筆垂直點在白紙上，長按開機鍵，會聽到點讀筆「開始」的聲音，注意在此期間筆頭不能離開白紙，直至聽到「I'm fine, thank you.」，才代表成功啟動四語功能。

7. 如果沒有聽到點讀筆的回應，請重複以上步驟。

如何使用新雅點讀筆閱讀故事？

1. 下載本故事系列的點讀筆檔案

1 瀏覽新雅網頁 (www.sunya.com.hk) 或掃描右邊的 QR code 進入 新雅・點讀樂園。

2 點選 **下載點讀筆檔案 ▶** 。

3 依照下載區的步驟說明，點選及下載 *Goose*（白鵝小菇故事系列）的點讀筆檔案至電腦，並複製至新雅點讀筆的「BOOKS」資料夾內。

2. 啟動點讀功能

開啟點讀筆後，請點選封面右上角的 新雅・點讀樂園 圖示，然後便可翻開書本，點選書本上的故事文字或圖畫，點讀筆便會播放相應的內容。

3. 選擇語言

如想切換播放語言，請點選內頁左上角的 ENG 粵 ☆ 普 圖示，當再次點選內頁時，點讀筆便會使用所選的語言播放點選的內容。

4. 播放整個故事

如想播放整個故事，請直接點選以下圖示：

5. 製作獨一無二的點讀故事書

爸媽和孩子可以各自點選以下圖示，錄下自己的聲音來說故事！

1 先點選圖示上 爸媽錄音 或 孩子錄音 的位置，再點 OK，便可錄音。

2 完成錄音後，請再次點選 OK，停止錄音。

3 最後點選 ▶ 的位置，便可播放錄音了！

4 如想再次錄音，請重複以上步驟。注意每次只保留最後一次的錄音。

爸媽請使用
這個圖示錄音

孩子請使用
這個圖示錄音

"Wake up, Goose!" says Sophie.

「小菇，起牀吧！」蘇菲說。

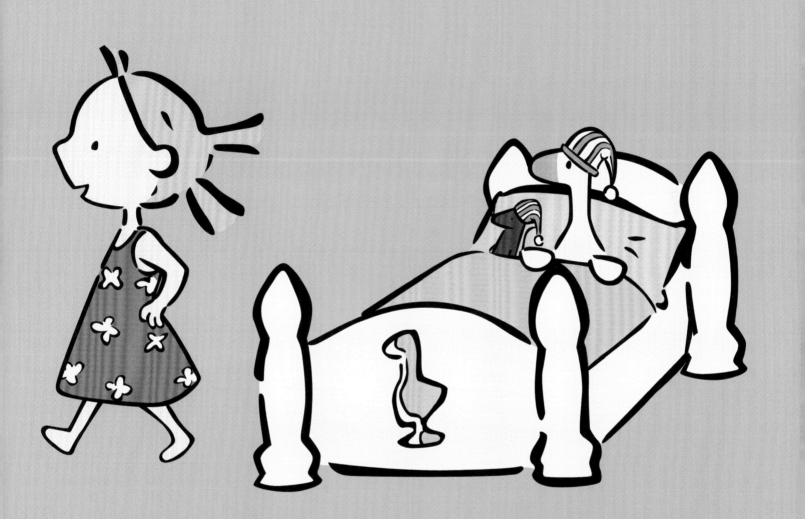

"The sun is shining. We're on holiday!"

「太陽都出來了！我們去度假吧！」

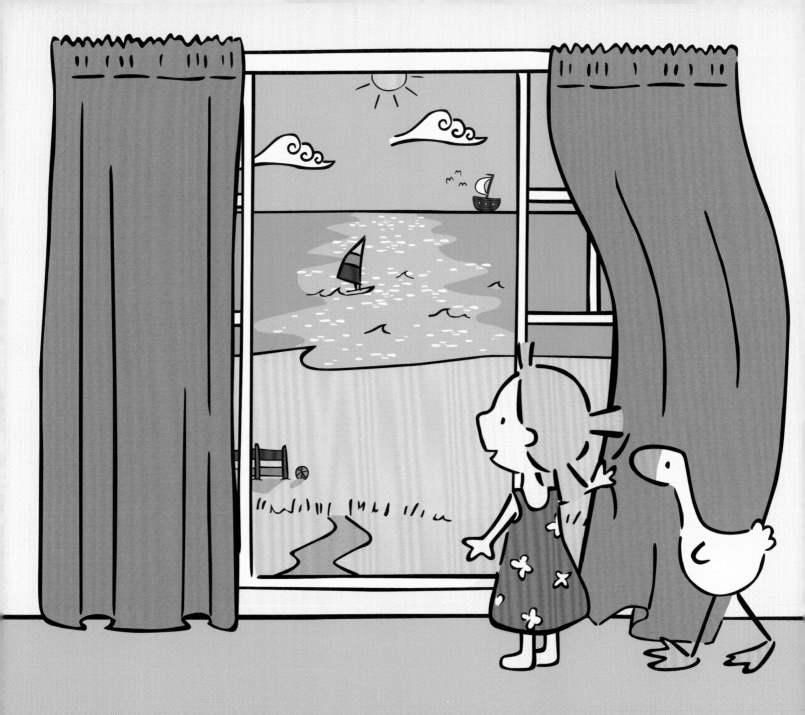

"Today we're going to the beach!"

「今天我們要去沙灘玩！」

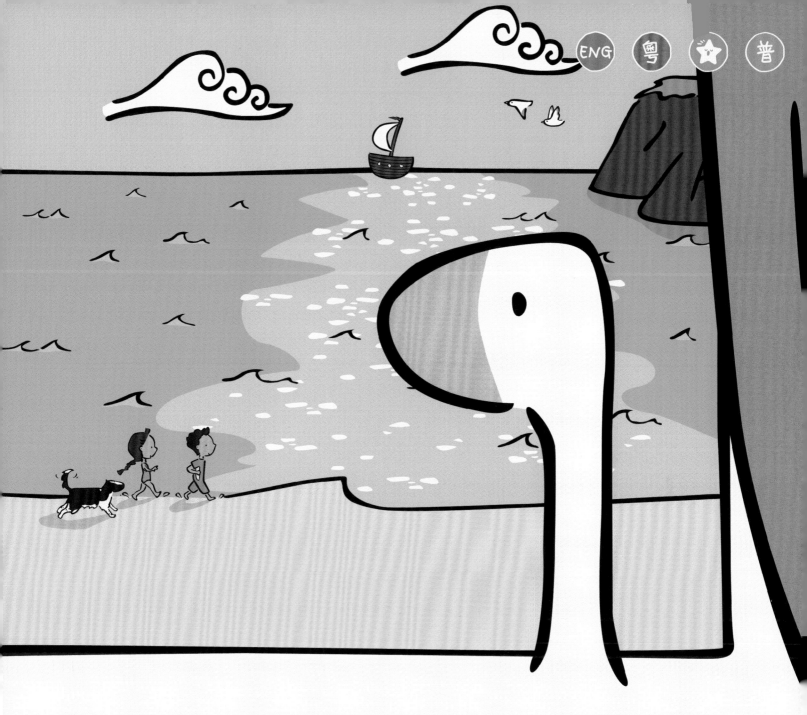

Goose has never been to the beach before.

小菇從來沒去過沙灘。

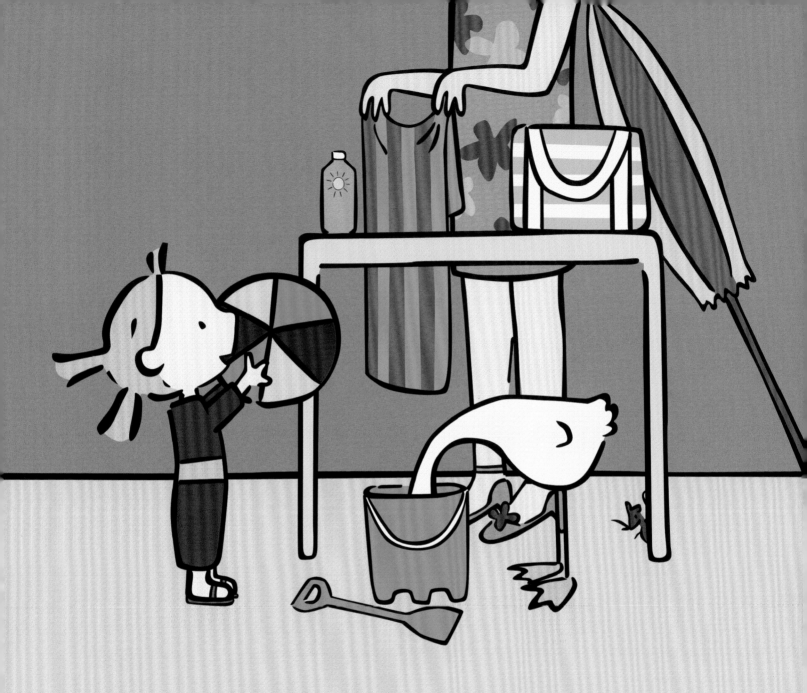

Sophie and Mum pack their things in a beach bag.

蘇菲和媽媽一起把東西放進沙灘袋裏。

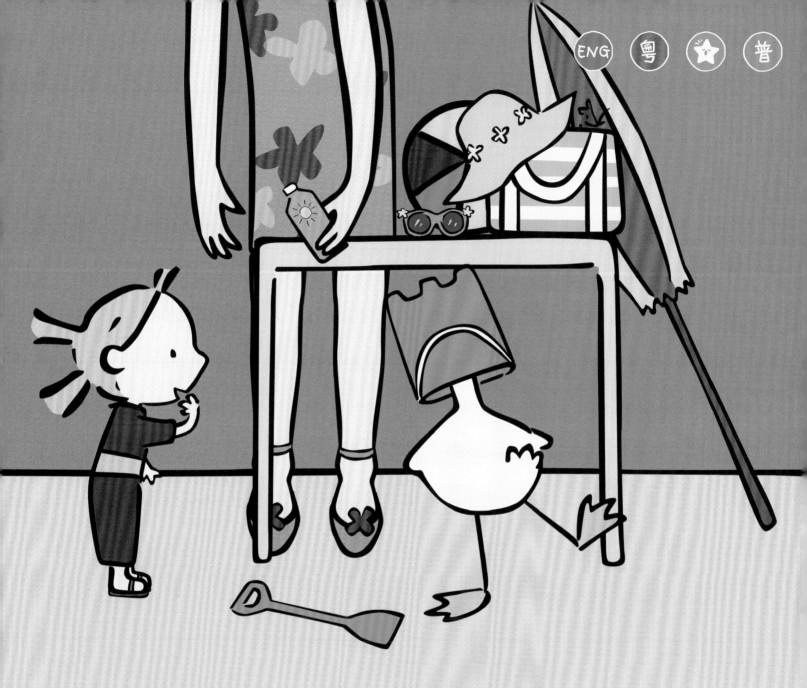

And they put on some sun screen.

然後她們塗上防曬霜。

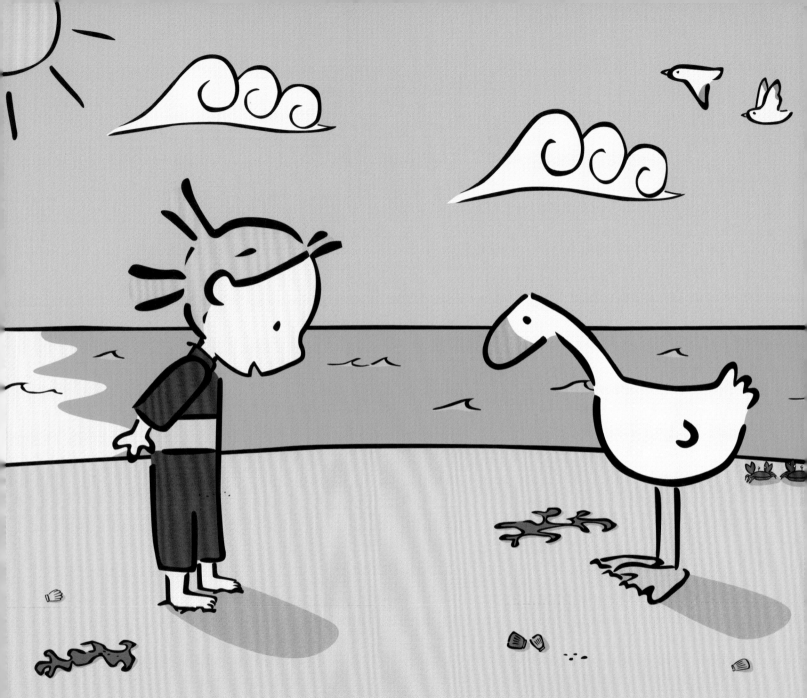

When they get to the beach,
Sophie wiggles her toes in the warm sand.

當他們到沙灘，蘇菲在温暖的細沙裏扭動着腳趾。

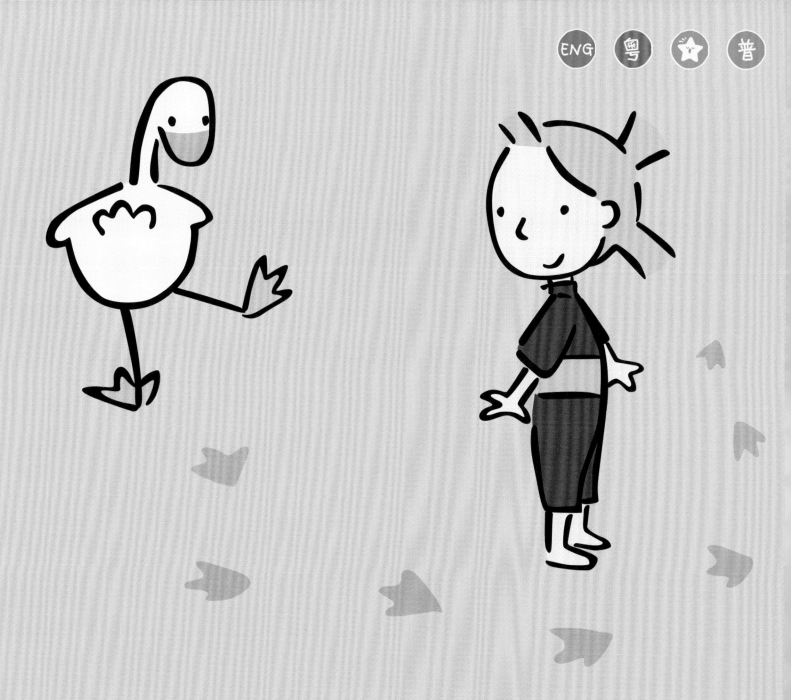

And Goose discovers he can make footprints!

小菇還發現他可以踏出很多腳印來！

This gives Sophie an idea.

這讓蘇菲想到一個主意。

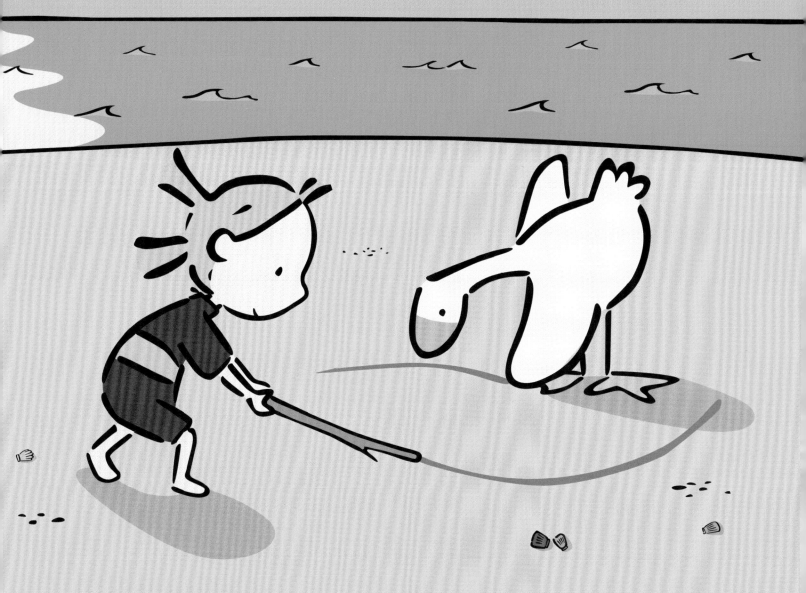

"Let's draw a picture in the sand!"

「我們在沙上畫畫吧！」

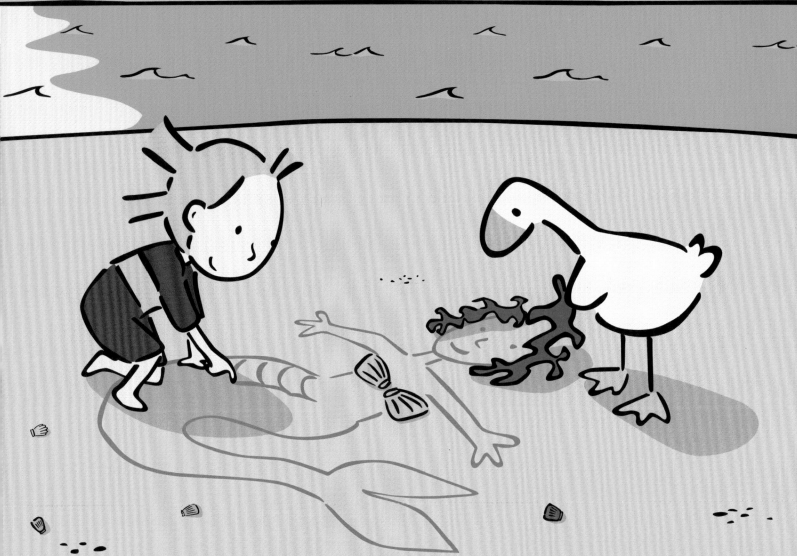

Goose finds some shells and seaweed
to make it extra special.

小菇找到一些貝殼和海藻，使這幅畫更加特別。

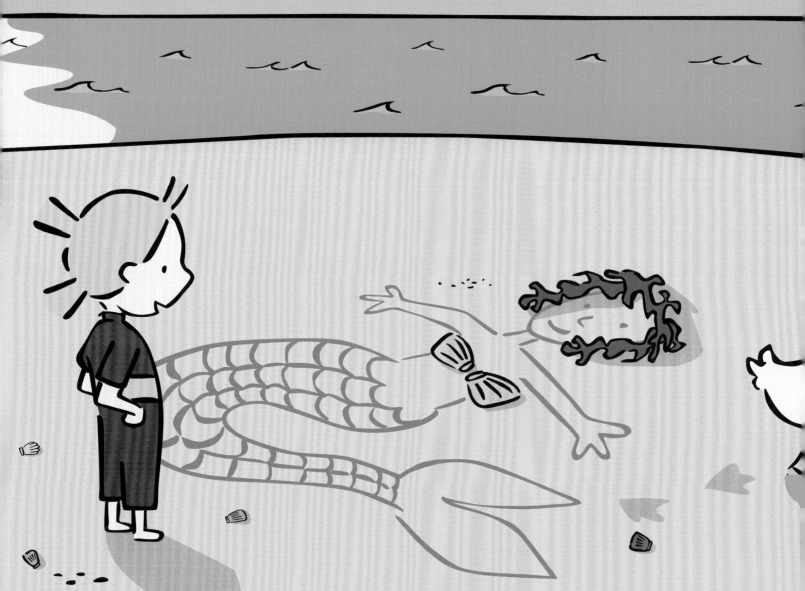

"What a lovely picture!" says Sophie.

「我們畫得真好！」蘇菲說。

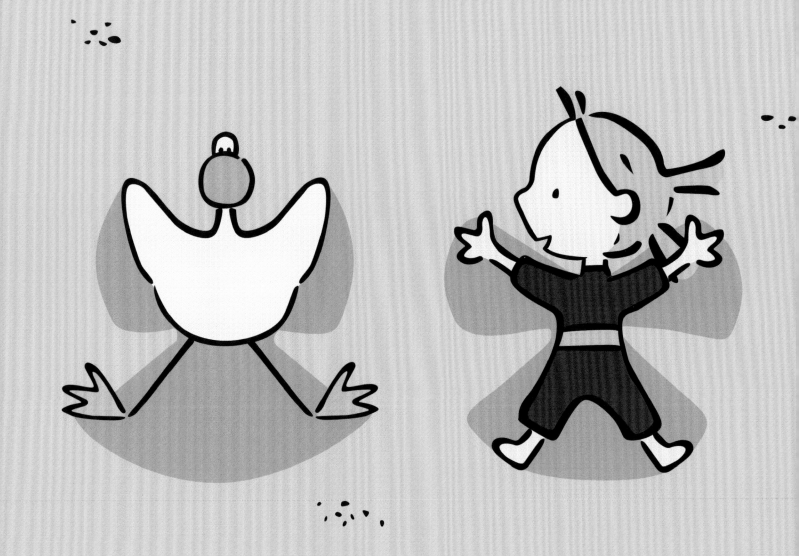

Goose and Sophie make sand angels.

小菇和蘇菲躺在沙上印出天使的圖形。

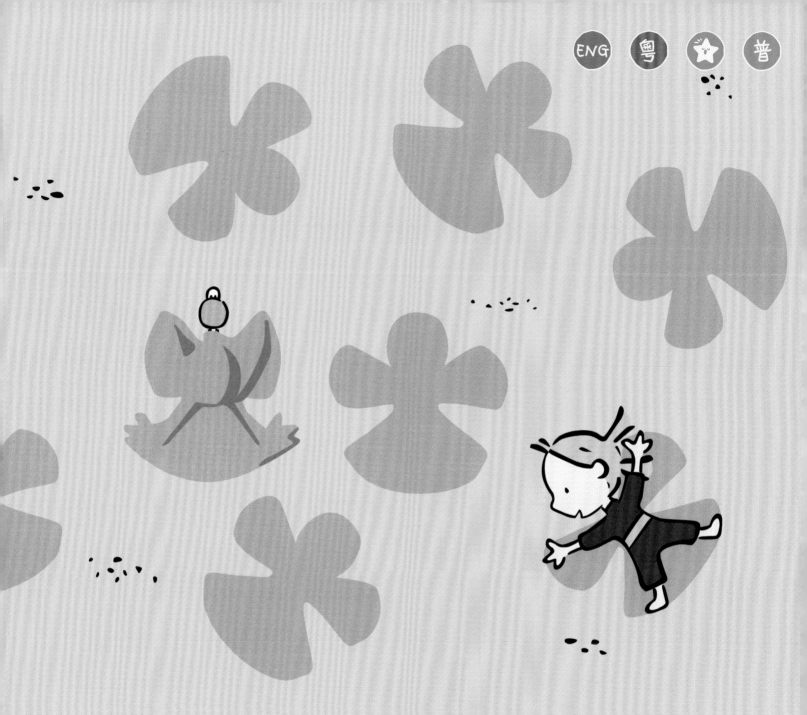

Lots of them!

很多沙天使！

But wait, where is Goose?

等等，小菇在哪裏？

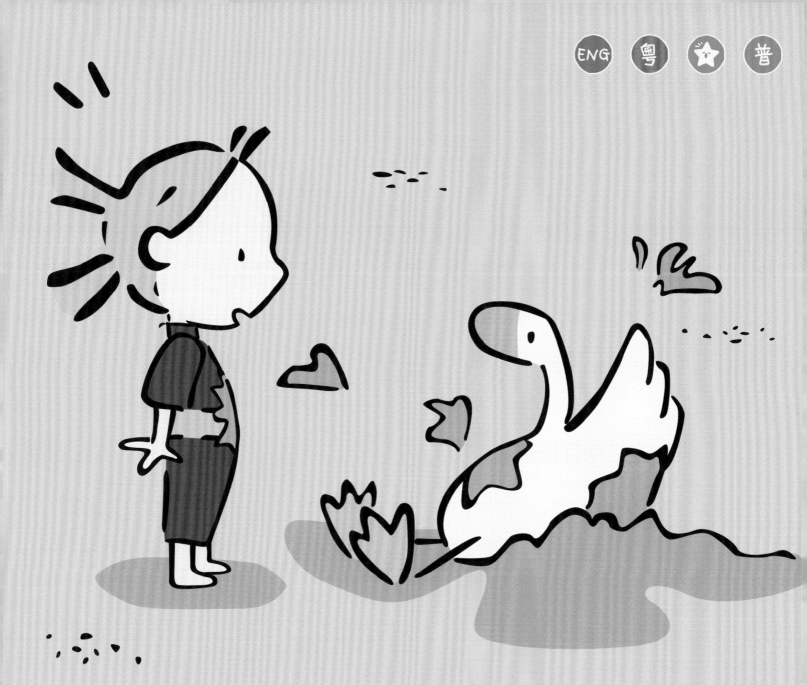

Surprise!

嘩！

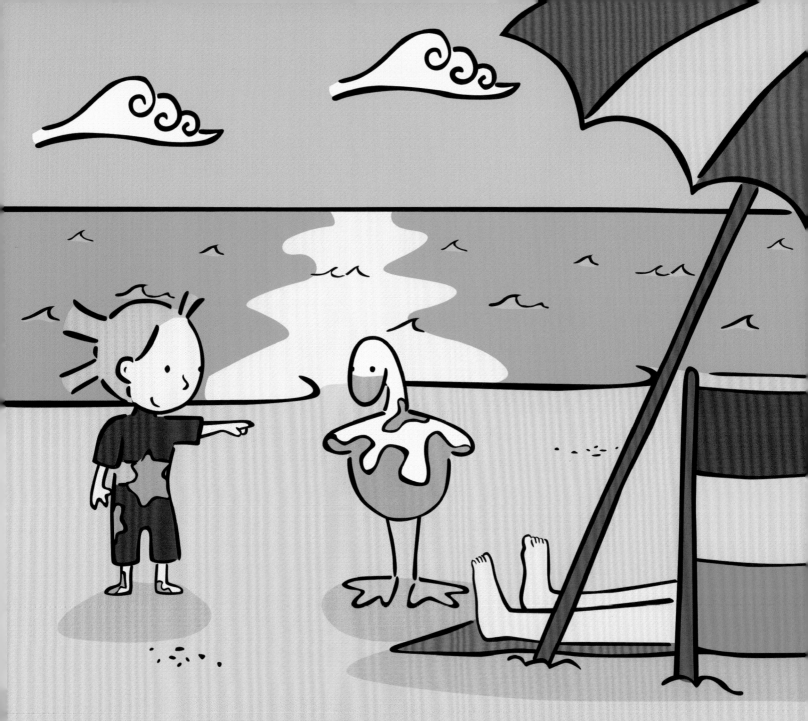

Sophie and Goose are all sandy.

蘇菲和小菇身上都沾滿了沙。

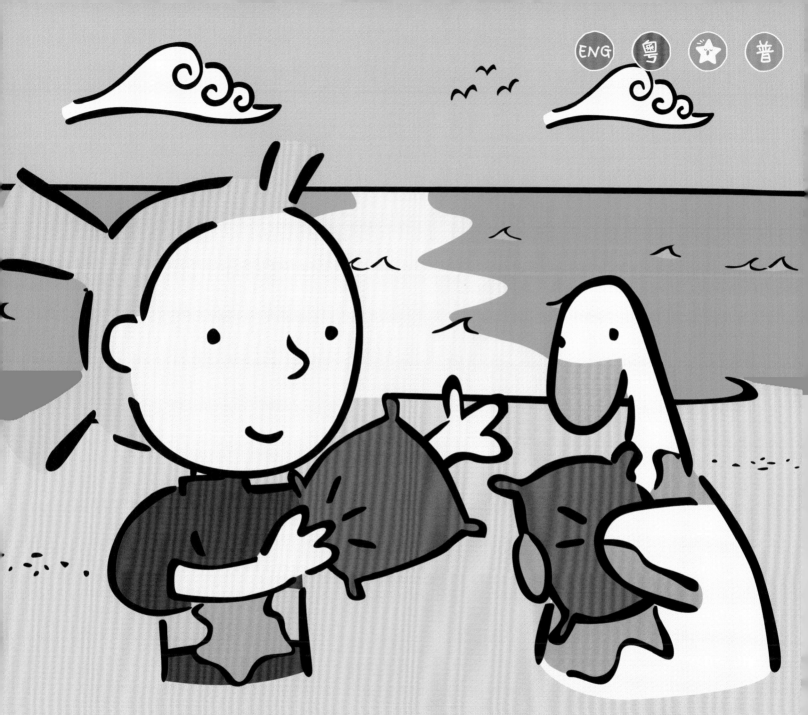

Mum suggests they wash it off in the water.

媽媽建議他們去水裏把沙洗掉。

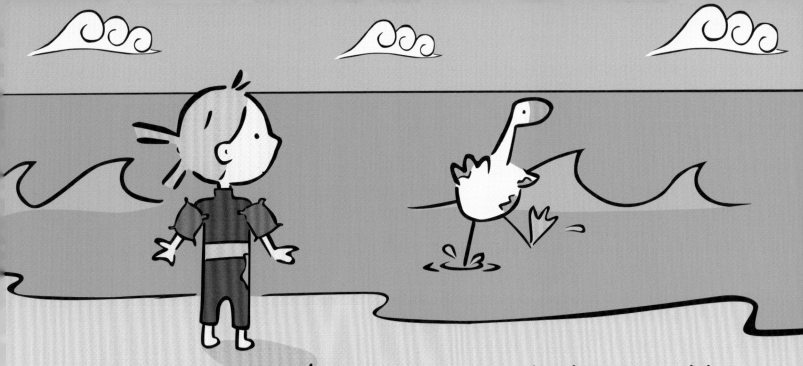

But Sophie isn't sure. The sea looks very big.

但蘇菲有點猶豫。這海看起來很大呢！

Goose takes her hand and they paddle together.

小菇牽着她的手，和她一起踏進水裏。

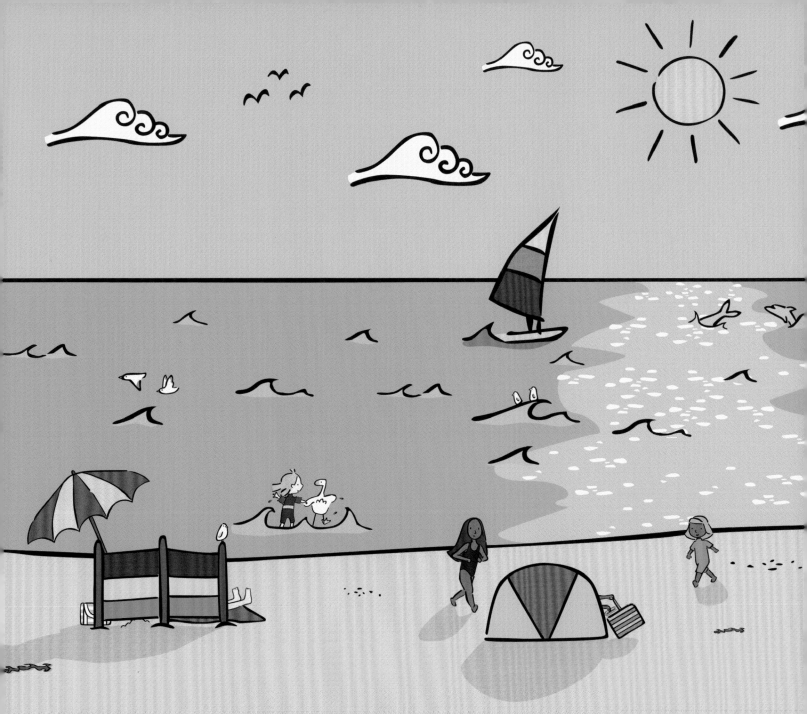

And jump in the waves.

還在海浪中跳來跳去。

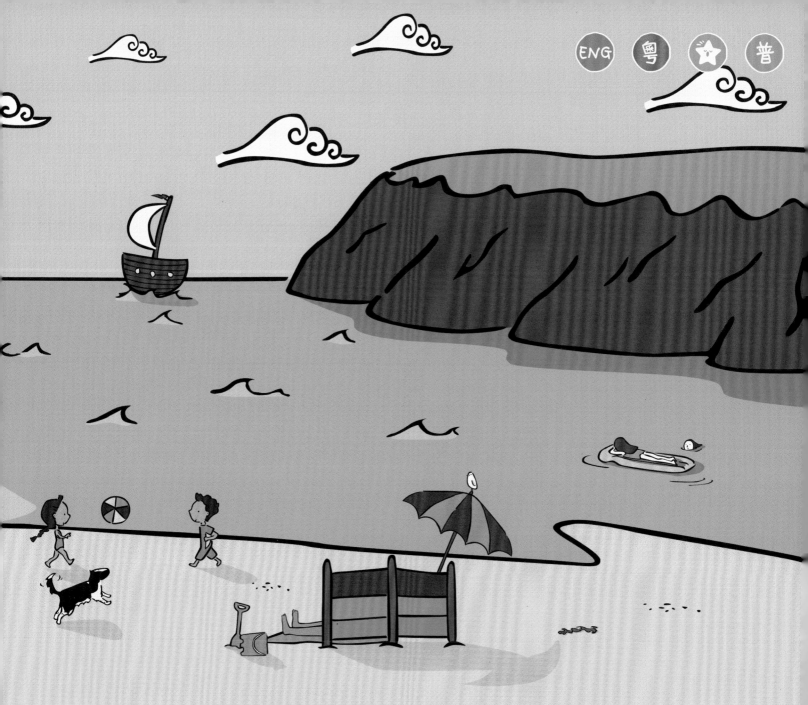

"This is so much fun!" laughs Sophie.

「太好玩了！」蘇菲大笑着說。

Playing in the water has made their tummies rumble.

在水裏玩久了，他們的肚子餓得咕嚕咕嚕地叫。

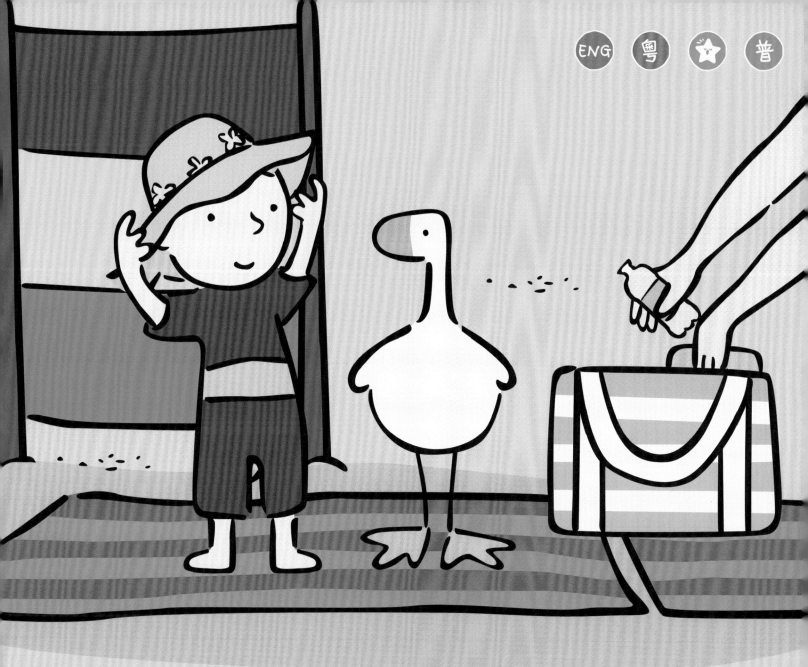

Sophie puts on her sun hat
while Mum gets the picnic ready.

蘇菲戴上太陽帽，等待媽媽把野餐準備好。

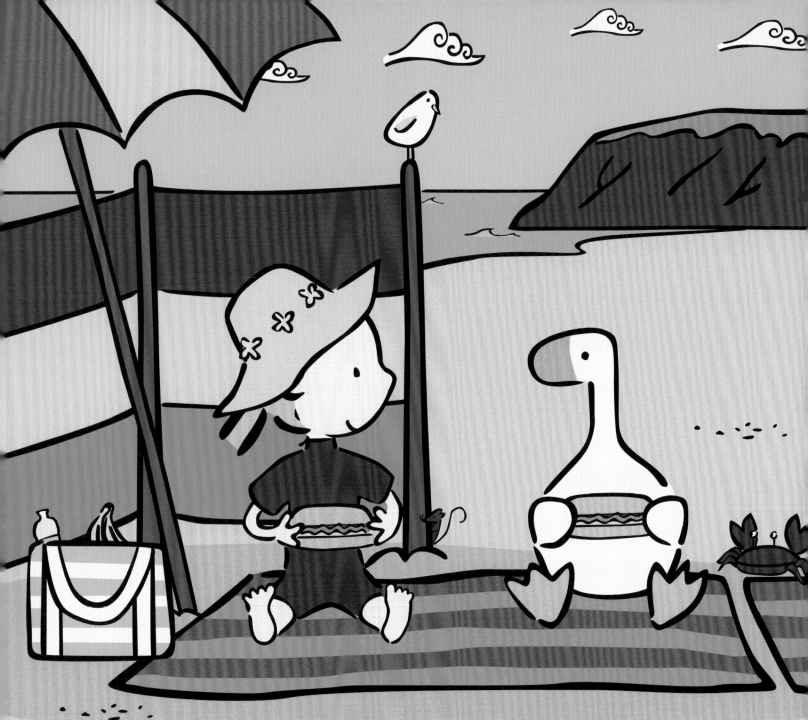

Sophie and Goose eat their lunch.

蘇菲和小菇一起吃午餐。

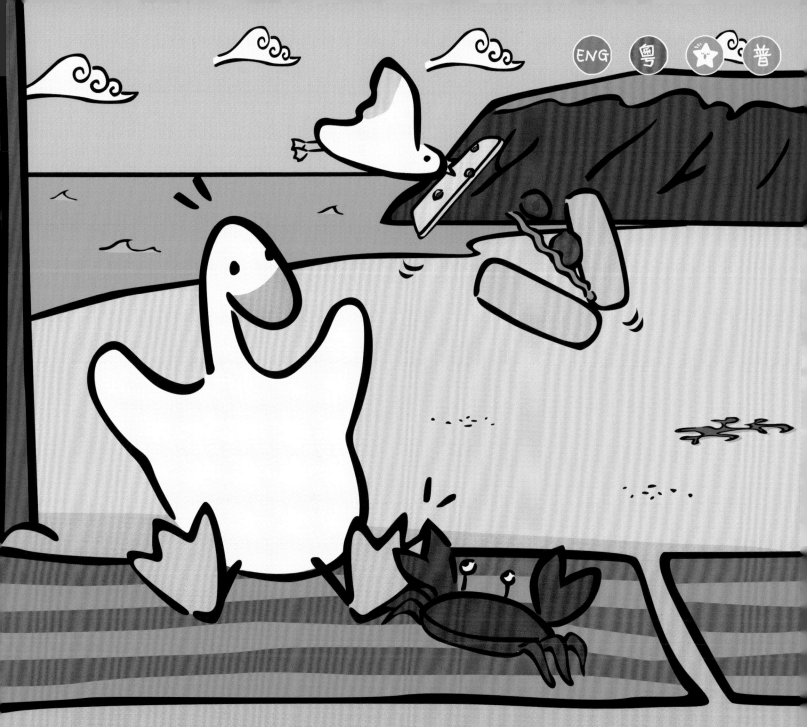

But someone wants to share Goose's food!

但有其他動物也想吃小菇的食物！

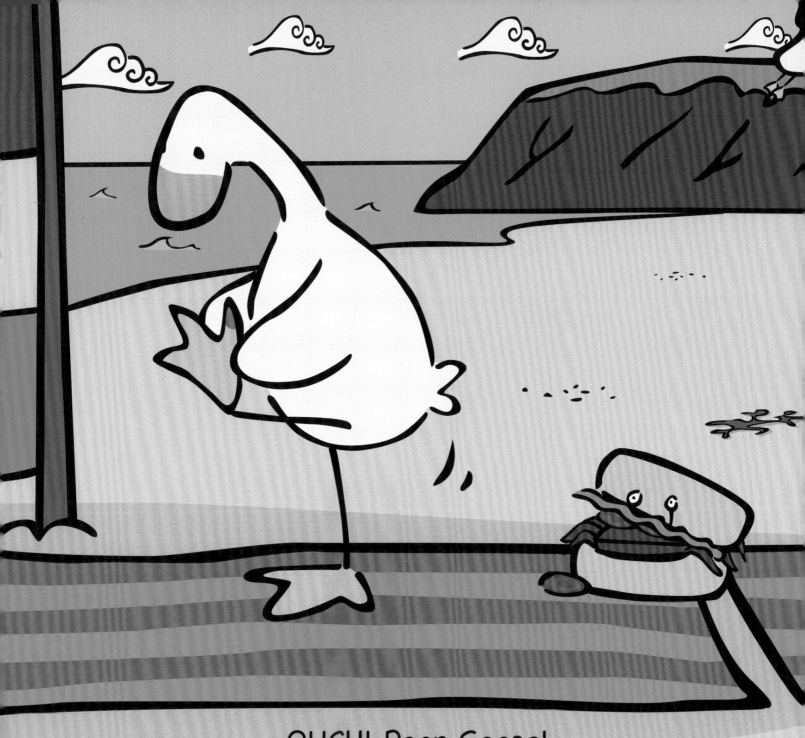

OUCH! Poor Goose!

哎喲！可憐的小菇！

"Perhaps an ice cream will cheer you up,"
suggests Sophie.

「也許雪糕能令你開心一點！」蘇菲建議說。

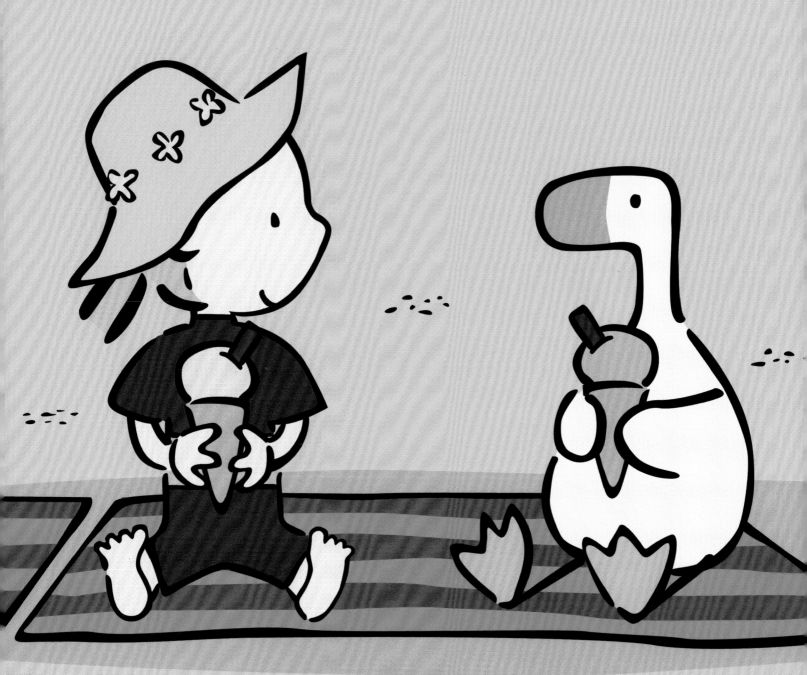

"Yum!"

「真好吃！」

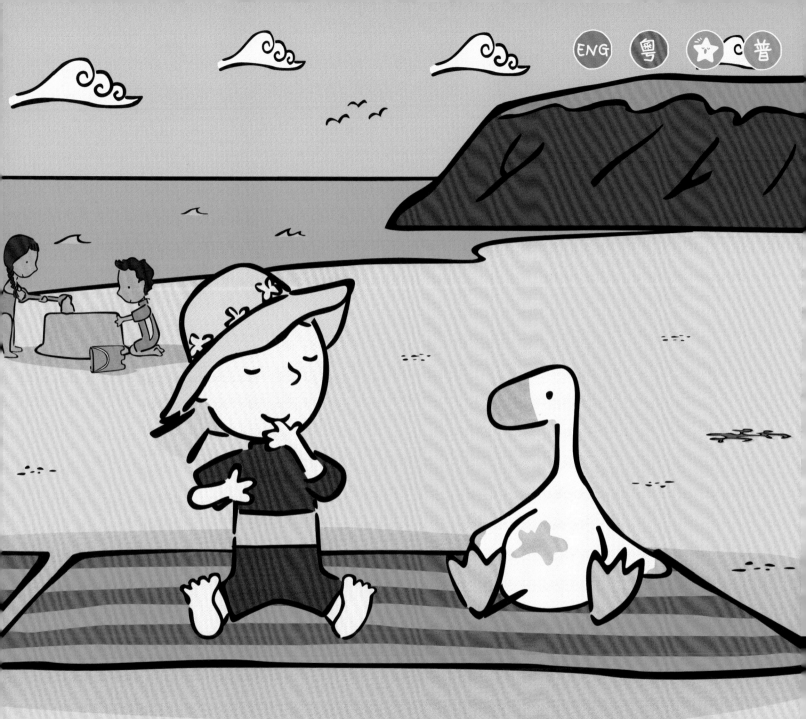

"Mmm!" smiles Sophie. "That was good!"

「嗯！」蘇菲笑着說，「真的很好吃！」

"Let's build a sandcastle!" says Sophie.

「我們來堆沙堡吧！」蘇菲說。

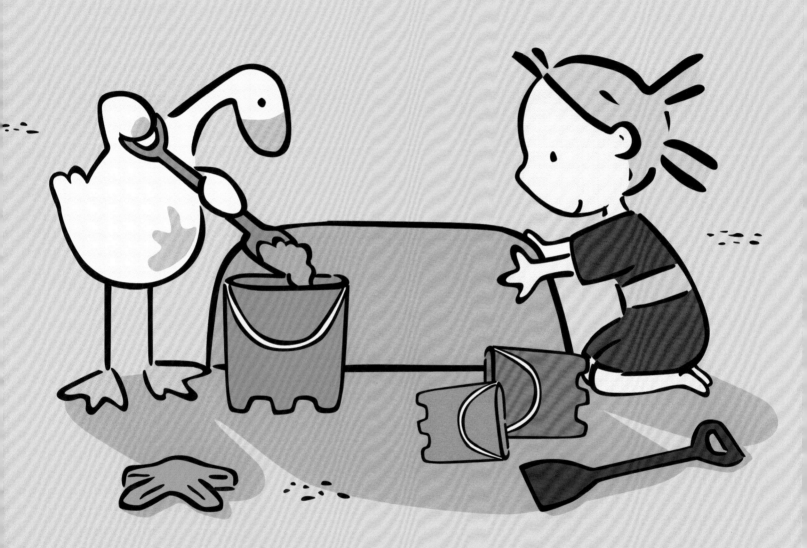

They set to work with their buckets and spades.

他們拿起小桶和小鏟子，開始動工。

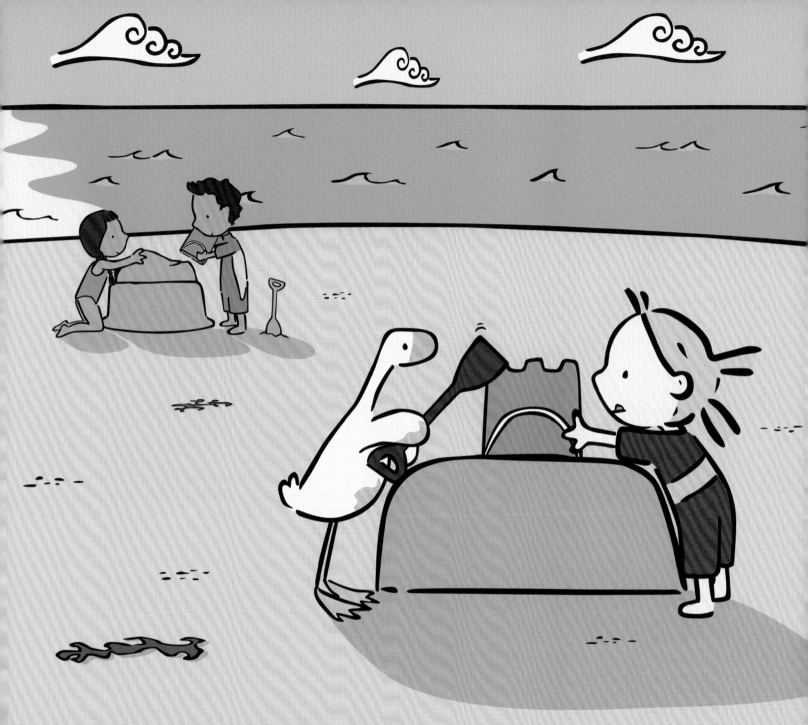

Sophie wants theirs to be the tallest on the beach.

蘇菲想堆一個全沙灘最高……

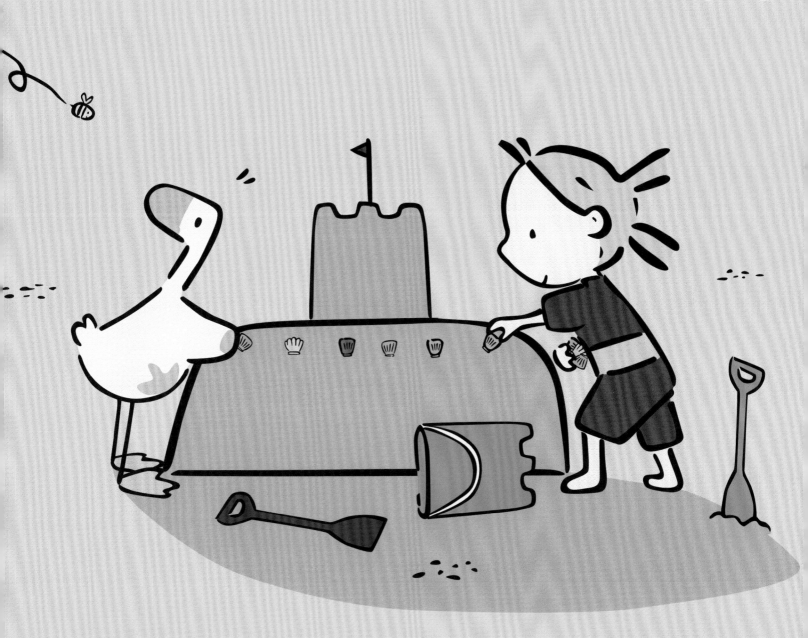

And the prettiest!

和最漂亮的沙堡！

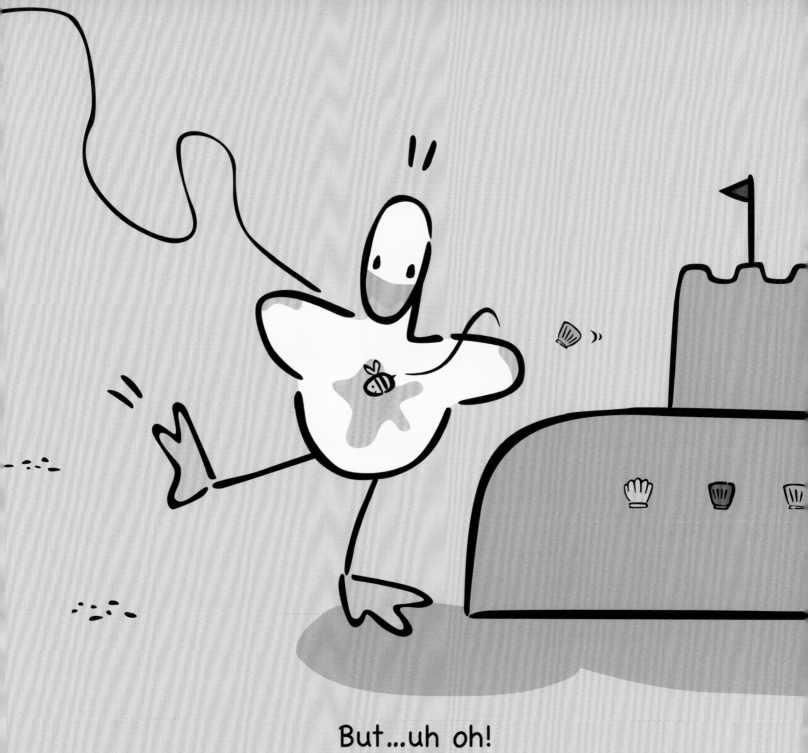

But...uh oh!

但是……不好了！

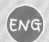 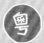

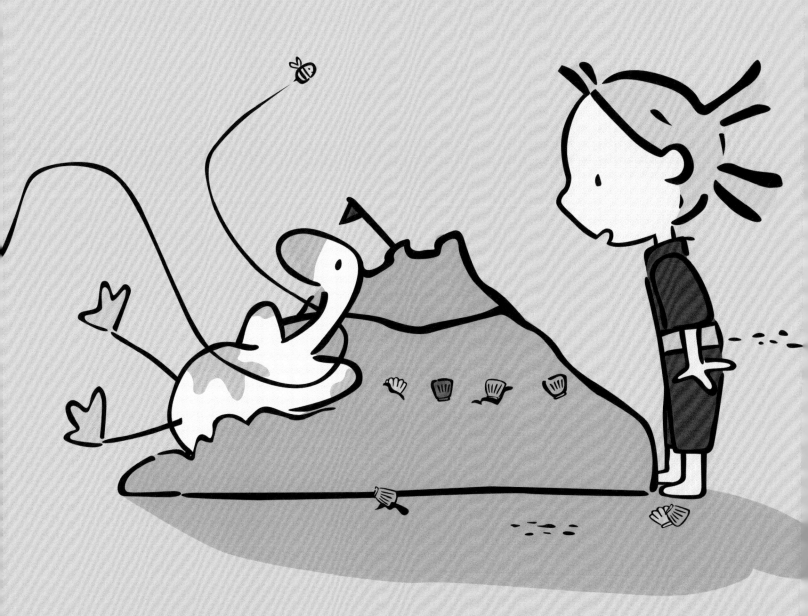

"Goose! Our sandcastle!" cried Sophie.

「小菇！我們的沙堡！」蘇菲驚叫。

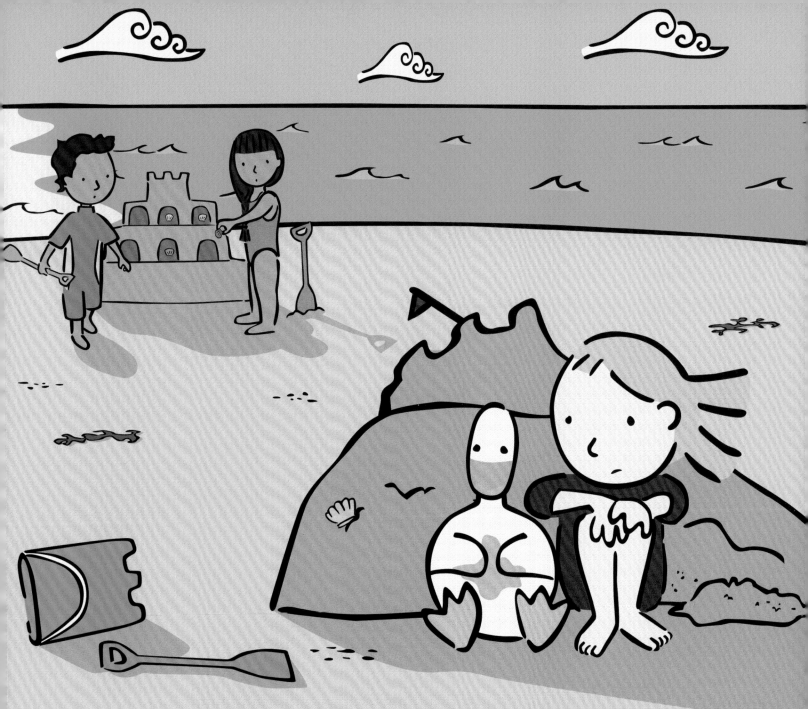

Goose is sad. Sophie is sad too.

小菇很難過。蘇菲也很難過。

Some children come to see what's wrong,
but Sophie can't understand them.

有兩個小朋友走過來，看看出了什麼事，
但蘇菲聽不懂他們的話。

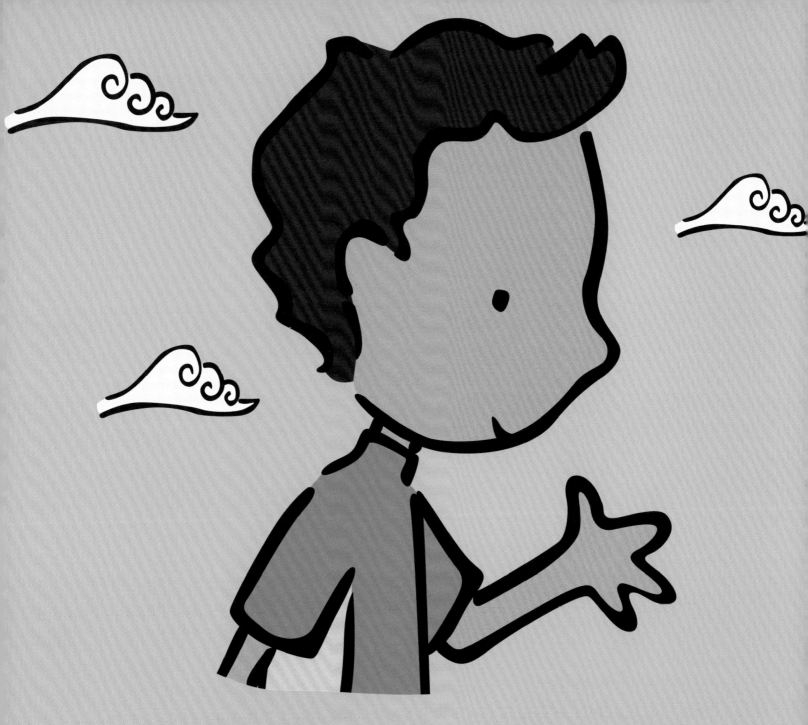

The boy smiles. Maybe he has an idea.

那男孩微笑。或許他想到了一個主意。

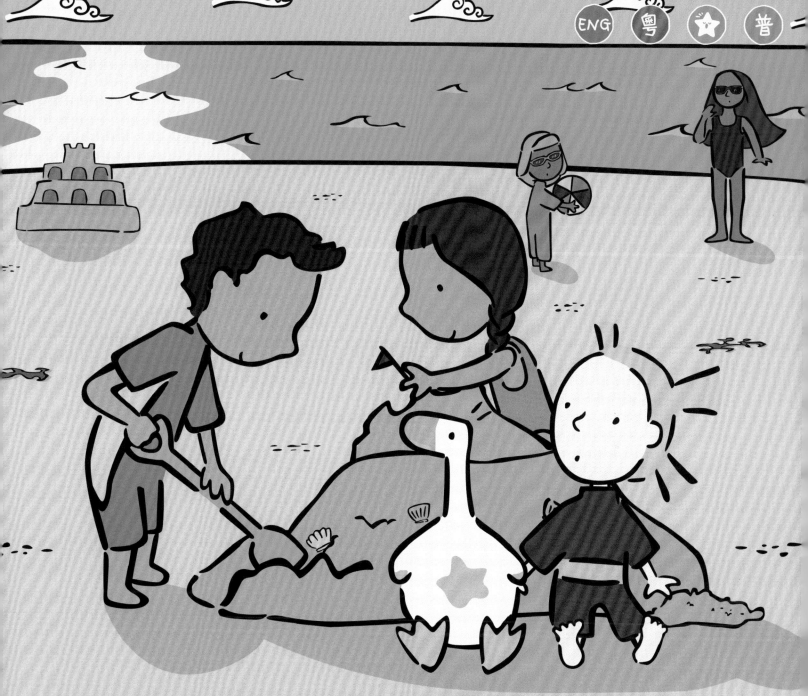

He starts to build a new sandcastle.

他開始重新堆一個沙堡。

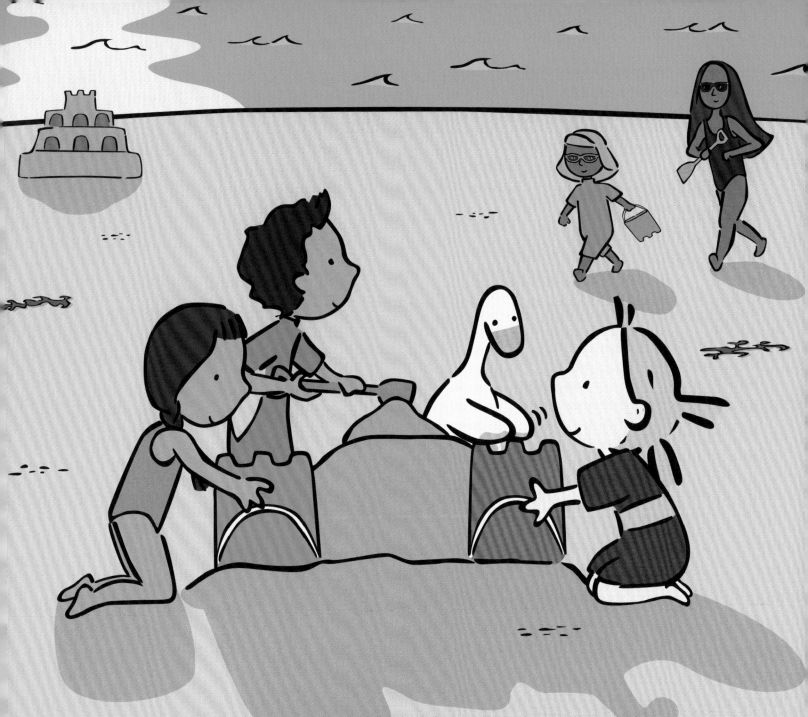

Soon more children come to help.

很快又有兩個小朋友來幫忙。

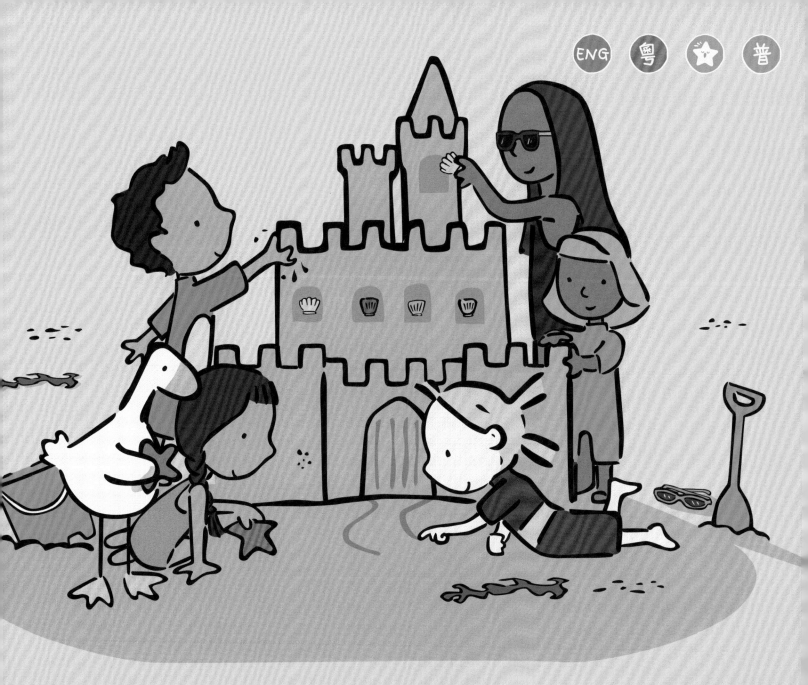

And together they build the biggest, most amazing sandcastle ever!

大家分工合作，堆出了一個最大、最棒的沙堡！

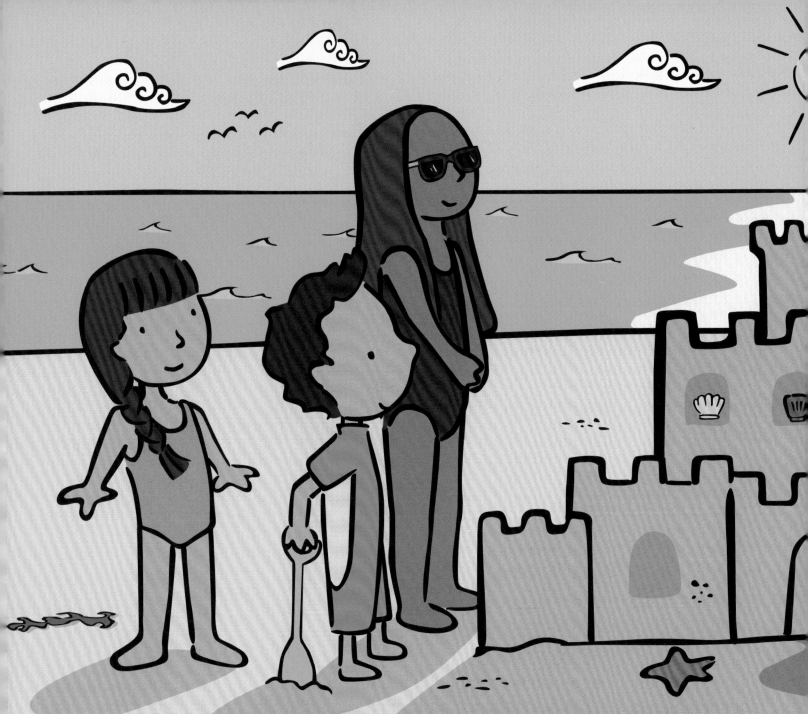

"What a beautiful sandcastle!" says Sophie.

「好漂亮的沙堡啊！」蘇菲說。

"Honk!" says Goose.

「呱！」小菇說。

Goose 白鵝小菇故事系列
Goose at the Beach 白鵝小菇去沙灘

圖　　文：蘿拉·華爾（Laura Wall）
翻　　譯：潘心慧
責任編輯：黃偲雅
美術設計：張思婷
出　　版：新雅文化事業有限公司
　　　　　香港英皇道499號北角工業大廈18樓
　　　　　電話：（852）2138 7998
　　　　　傳真：（852）2597 4003
　　　　　網址：http://www.sunya.com.hk
　　　　　電郵：marketing@sunya.com.hk
發　　行：香港聯合書刊物流有限公司
　　　　　香港荃灣德士古道220-248號荃灣工業中心16樓
　　　　　電話：（852）2150 2100
　　　　　傳真：（852）2407 3062
　　　　　電郵：info@suplogistics.com.hk
印　　刷：中華商務彩色印刷有限公司
　　　　　香港新界大埔汀麗路36號
版　　次：二〇二三年五月初版

ISBN : 978-962-08-8163-3
Original published in English as 'Goose at the Beach'
© Award Publications Limited 2012
Traditional Chinese Edition © 2023 Sun Ya Publications (HK) Ltd.
18/F, North Point Industrial Building, 499 King's Road, Hong Kong
Published in Hong Kong SAR, China
Printed in China